THE LAND BEFORE TIME™

HOW TO DRAW DINOSAURS

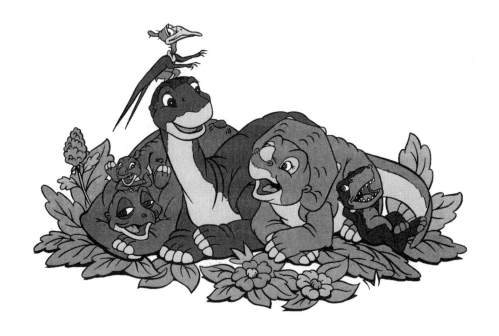

by Q. L. Pearce

drawing steps illustrated by Neal Yamamoto

LOWELL HOUSE JUVENILE

LOS ANGELES

NTC/Contemporary Publishing Group

To Gina: the girl who likes
to draw—Q. L. P.

Published by Lowell House
A division of NTC/Contemporary Publishing Group, Inc.
4255 West Touhy Avenue, Lincolnwood (Chicago), Illinois 60646-1975 U.S.A.

Managing Director and Publisher: Jack Artenstein
Director of Publishing Services: Rena Copperman
Editorial Director: Brenda Pope-Ostrow
Project Editor and Drawing Steps: Amy Downing
Designer: Victor W. Perry

Library of Congress Catalog Card Number: 99-73110
ISBN 0-7373-0237-2

Printed and bound in the United States of America

RCP 10 9 8 7 6 5 4 3 2 1

Contents

Anatosaurus

Anatosaurus was a duck-billed dinosaur of the Cretaceous period. It was a real prize-winner when it came to teeth. The hundreds of teeth arranged in tightly packed rows helped the 30-foot-long plant-eater to grind up tough meals of pine needles, twigs, seeds, and fruit. Anatosaurus had fleshy pads on its front feet and walked mainly on all fours. However, when it needed to make a quick getaway, it could run on its two back legs with its tail held straight out behind for balance. Anatosaurus is also known as **edmontosaurus**.

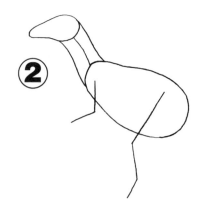

① First draw a large jelly bean shape for the dinosaur's body. Add a small head, and connect the two with a straight line.

Thicken the neck as shown, and add guidelines for the near arm and leg. **②**

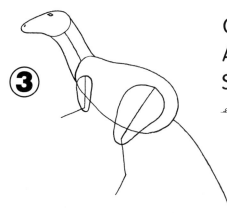

③ Outline the near upper arm and leg.
Add a long guideline for the tail.
Sketch an eye and nostril in the head.

Outline the tail, lower arm, and
middle section of the leg. Lightly
draw in the dinosaur's mouth and
an eyebrow, and outline the nostril.

④

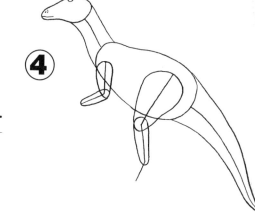

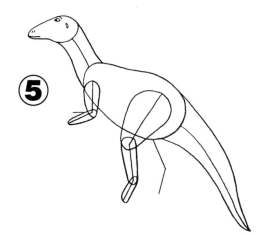

⑤ Fill in the lower leg, and begin to sketch
the far arm and leg. Add a pupil in the
eye and an open slit behind the eye.

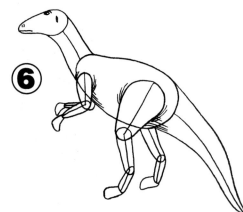

6 Thicken the far arm and leg, and begin to shade under and around the near arm and leg. Add shapes for the hands and feet.

Begin to detail the claws of the hands and feet. **7** Add a thin fold of skin under the head and neck. Further shade the dinosaur as shown.

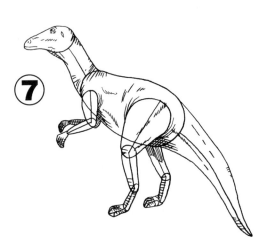

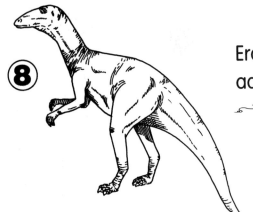

8 Erase all unneeded guidelines, and add finishing details as you wish.

FUN FACT

Two anatosaurus mummies were found with their stomach contents intact. The last meal they had eaten included twigs, seeds, pine needles, and fruit.

Apatosaurus used to be called brontosaurus, or "thunder lizard," because it was so huge that the ground probably shook when it walked. It weighed more than 30 tons. That's about as heavy as six adult African elephants. The 75-foot-long jumbo Jurassic dinosaur was a plant-eater, and it chowed down on a lot of green stuff to keep itself fed. It ate about 500 pounds of leaves every day. Apatosaurus gulped down a few stones now and then, too. The

stones stayed in its stomach and rolled around when the dinosaur was eating. That crunched up the food, making it easier to digest.

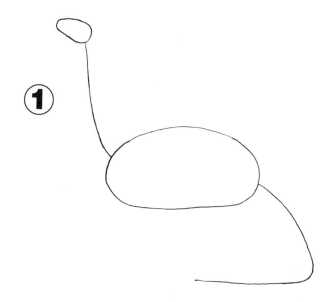

1

To begin, draw the large body and small head of apatosaurus. Add guidelines for the long neck and tail.

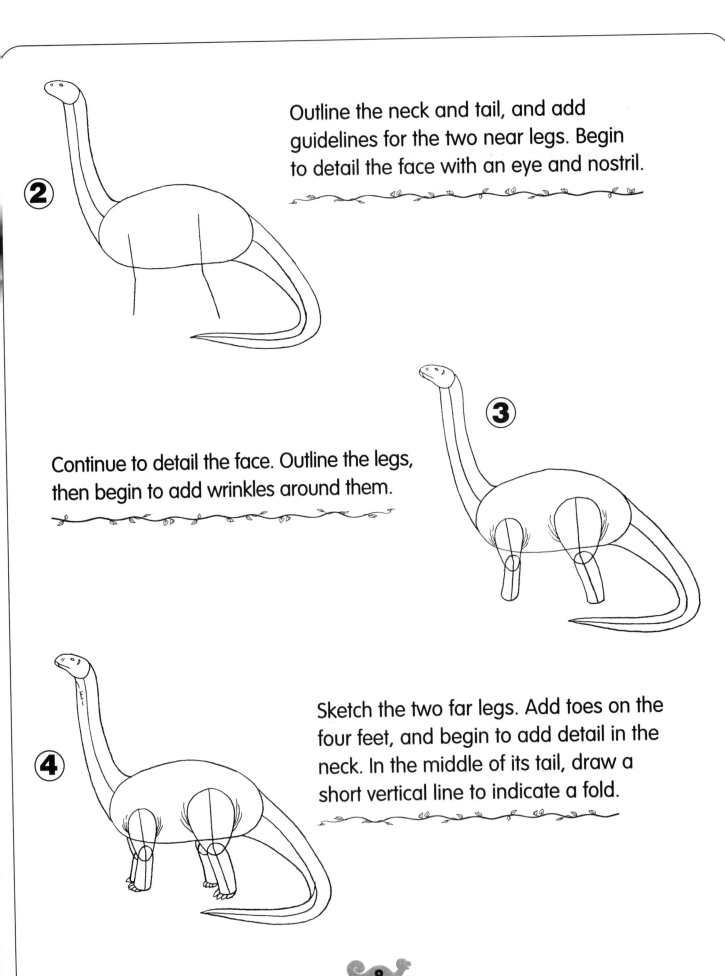

② Outline the neck and tail, and add guidelines for the two near legs. Begin to detail the face with an eye and nostril.

Continue to detail the face. Outline the legs, then begin to add wrinkles around them.

③

④ Sketch the two far legs. Add toes on the four feet, and begin to add detail in the neck. In the middle of its tail, draw a short vertical line to indicate a fold.

Shade the far legs, then continue to detail its head, neck, body, tail, and legs. Indicate claws on the toes, and shape the dinosaur's head as shown.

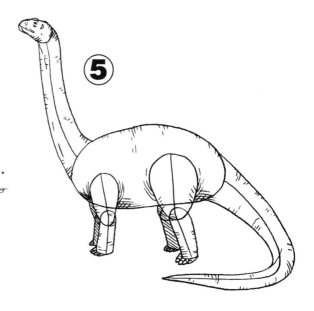

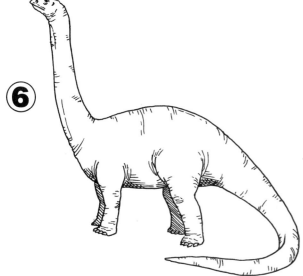

Erase all unneeded lines. Fill in the eye, and add any finishing touches you wish.

FUN FACT

When threatened, apatosaurus could use its long tail as a weapon to knock the enemy off its feet.

Baryonyx

Baryonyx had a strange-looking snout compared to other dinosaurs. It was long, like that of a crocodile, and it was filled with about 128 sharp teeth. That's nearly twice the number for other Cretaceous meat-eaters. Baryonx used its chompers on fish that it caught with a 12- to 15-inch-long claw on each hand. It would crouch down on the shore of a lake or riverbank like a 30-foot-long, 2-ton statue and wait for a meal to swim close. With a lightning-quick swipe of its hand, dinner was served.

①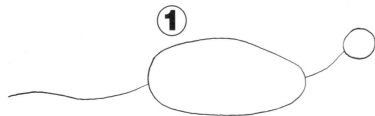

Draw the creature's rounded body and head. Sketch guidelines for its neck and tail.

Outline the neck and tail, then add a large snout. Sketch an eye and nostril. Draw guidelines for the two near legs.

②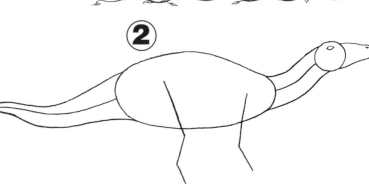

③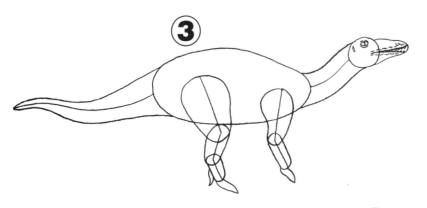

Outline the legs. Begin to add the first of its three toes on the near feet, and one dewclaw. Continue to detail the eye, nostril, and open mouth. Add a small slit behind the eye.

Sketch the two far legs, partially hidden. Add two more toes on each foot, and indicate the claws. Begin to add wrinkles around the legs.

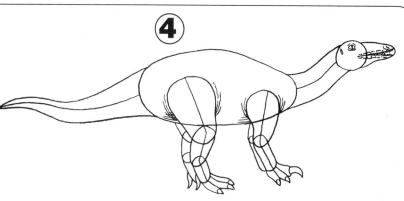

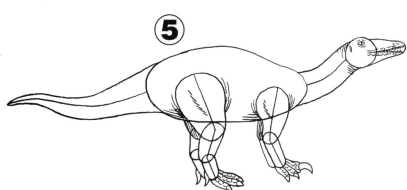

Detail the near feet with scales, and continue to shade the four legs and neck.

Erase all the guidelines, and add a few more scales going up the near legs. Last, add light shading and texture lines around its curved body, neck, tail, and legs.

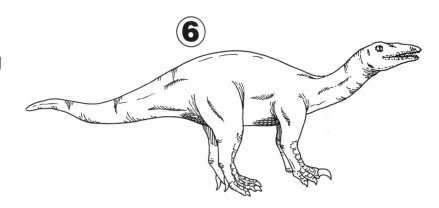

FUN FACT

Baryonyx lived near what is now London, England, near the shores of a lake that covered much of northern Europe.

How to Draw Dinosaurs

Brachiosaurus

The Jurassic period was the age of giants, and brachiosaurus fit in just perfectly. Brachiosaurus weighed up to 80 tons, was 80 feet long, and was tall enough to eat leaves and twigs from the treetops. Unlike most other dinosaurs, its front legs were longer than its back legs. That is how it got its name, which means "arm lizard."

1 First draw the large round body and the small head. Draw a guideline to connect the two, then outline its neck. Add a small triangular shape for its snout.

Draw the lower portion of its mouth. Add guidelines for the four legs and tail. **2**

3 Add a small bump on its head, as well as the small eye and slit behind the eye. Outline the four legs and tail. Add toes on its two front feet.

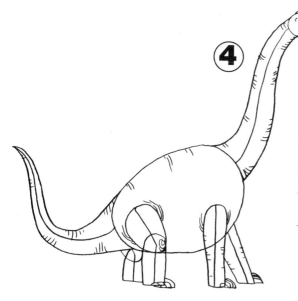

④

Continue to detail the head by adding teeth. Sketch toes on the remaining foot, and draw rounded texture lines around the sides of its tail, body, neck, and legs.

⑤

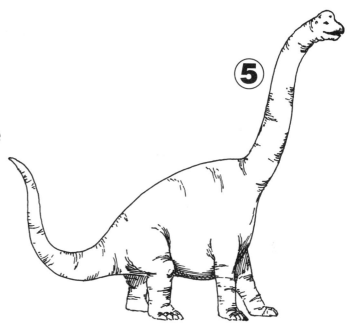

Fill in the eye and mouth, and erase all unneeded lines. Finish your dinosaur by shading its underside and wherever else you wish.

FUN FACT

Brachiosaurus' nostrils were on the top of its head.

Coelophysis

Coelophysis came on the scene early in the dinosaur age. It lived during the Triassic period and spent its time chasing any creature it could catch to eat. A fully grown adult weighed about 100 pounds, so its prey was limited to small critters such as insects, reptiles, and early mammals. With its long tail included, it stretched to 10 feet long and stood no taller than a 12-year-old kid.

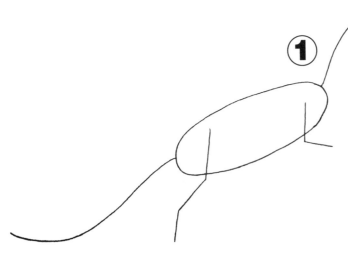

1

Draw a long oval and, to its right, a small circle. Sketch guidelines for the neck, tail, and the near arm and leg.

Draw a guideline for the back leg, and add a snout shape. Begin to outline the upper legs and arm, as well as the neck and tail.

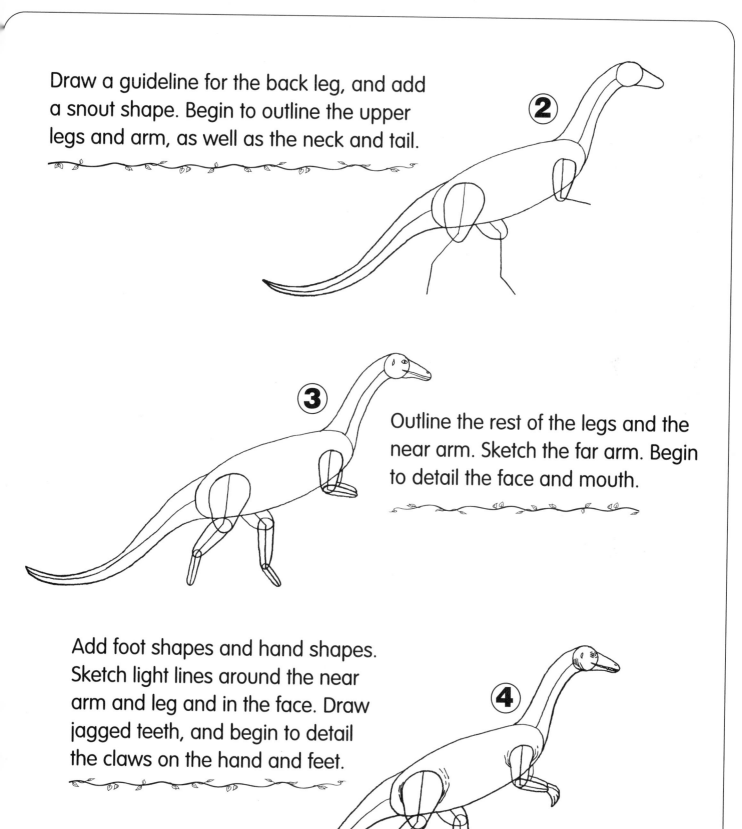

Outline the rest of the legs and the near arm. Sketch the far arm. Begin to detail the face and mouth.

Add foot shapes and hand shapes. Sketch light lines around the near arm and leg and in the face. Draw jagged teeth, and begin to detail the claws on the hand and feet.

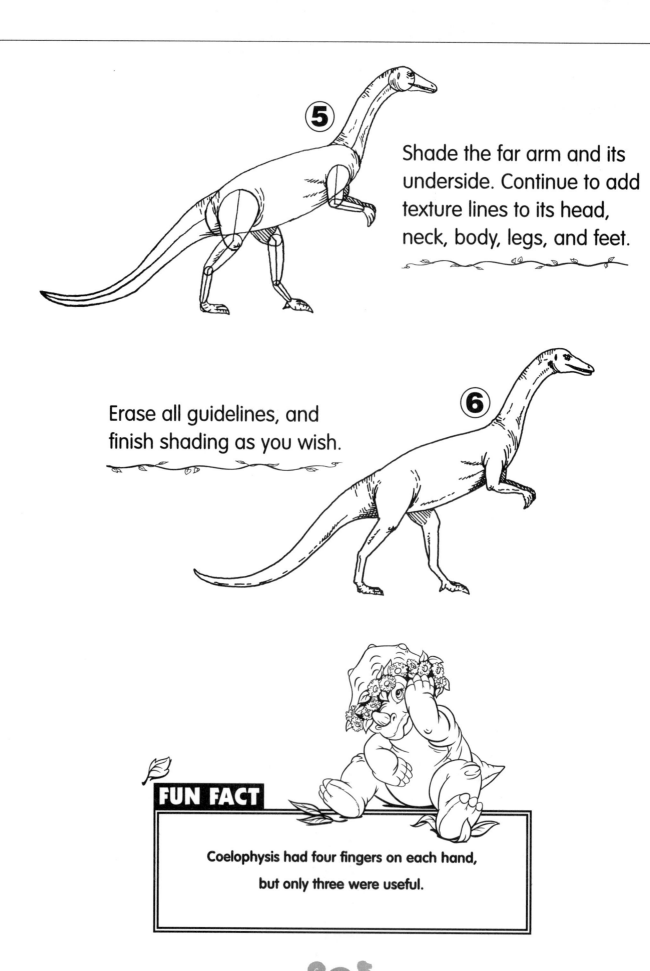

5

Shade the far arm and its underside. Continue to add texture lines to its head, neck, body, legs, and feet.

Erase all guidelines, and finish shading as you wish.

6

FUN FACT

Coelophysis had four fingers on each hand,

but only three were useful.

Deinonychus

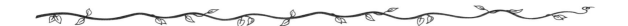

The name deinonychus means "terrible claw." Take one look at this Cretaceous meat-eater and you know why! On each back foot it had a 5-inch-long, sickle-shaped claw that it used to slash at and rip open its kill. Deinonychus was about 12 feet long, 5 feet tall, and weighed about 150 pounds. What it lacked in size, it made up for in fierceness. It had excellent eyesight, large jaw muscles, daggerlike teeth, and powerful, grasping hands. Deinonychus was a tough character, and the fact that it hunted in packs made it a plant-eater's nightmare.

Draw the dinosaur's head and body, then connect them with a thin line. Add guidelines for the tail and arms. Sketch a snout, overlapping it into the head.

Add its eye and mouth. Outline
the neck and tail, and draw a
guideline for its back leg.

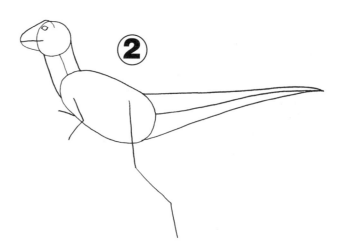

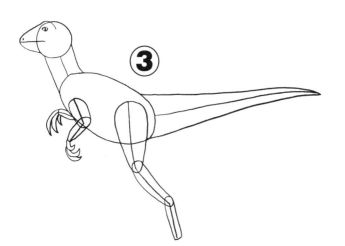

Add a nostril and a pupil in its
eye. Outline the arms and leg.
Add curved claws on the arms.

Sketch toes on the back near leg.
Draw the back far leg, which is
bent in a running position. Begin
to detail with short lines around
its neck, back, and face.

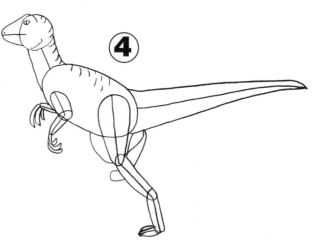

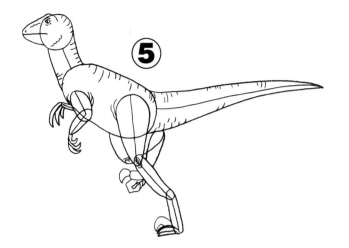

⑤

Continue to detail its head, body, and tail. Don't forget to add wrinkle lines around its arm and leg. Draw in the huge claw on each back leg, and add its curled toes on its far back leg.

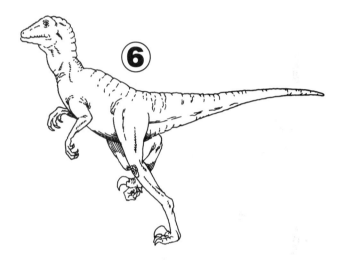

⑥

To complete deinonychus, erase all unneeded lines. Add small, rough bumps on its head and down its neck and back. Detail the claws, and add texture where you wish.

FUN FACT

Deinonychus would stand on one foot and slash its prey with the claw of the other foot, all the while using its tail for balance.

You wouldn't want to challenge gallimimus to a race. According to some estimates, this 15- to 20-foot-long, 400-pound speed demon could sprint as fast as 35 miles per hour. That made gallimimus, or "rooster mimic," able to get away from Cretaceous predators and also able to catch small prey. When it wasn't in the mood for the chase, this beaked, toothless dinosaur ate eggs.

① Draw a horizontal pear shape for its body and a small circle for the head. Sketch guidelines for the neck and tail.

Add its beak, and outline the neck and tail. Sketch guidelines for the legs and arms.

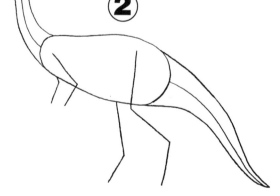

②

Outline the near arm and leg. Begin to detail the face and beak.

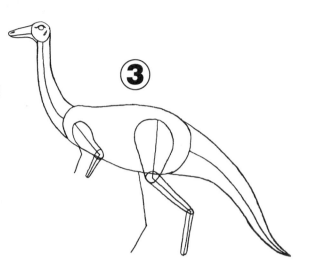

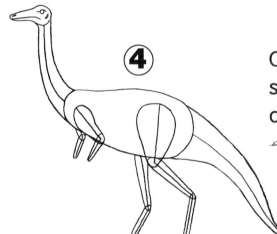

Outline the far arm and leg. Further shape the beak. Erase the line connecting the beak to the head.

Draw two claws on each arm and leg. Begin to shade gallimimus, and add detail to the beak.

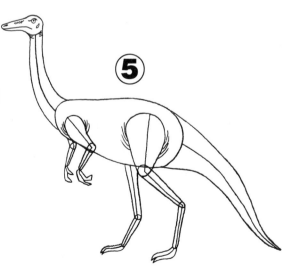

6

Add a third claw on each arm and leg. Continue shading its neck and body.

Detail the arms and legs with short horizontal lines. Add short texture strokes along its neck, back, and tail.

7

8

To finish, erase unneeded lines, and continue to shade gallimimus as you wish.

FUN FACT

Gallimimus was the largest of the ornithomids ("bird mimics"), sometimes called ostrich dinosaurs.

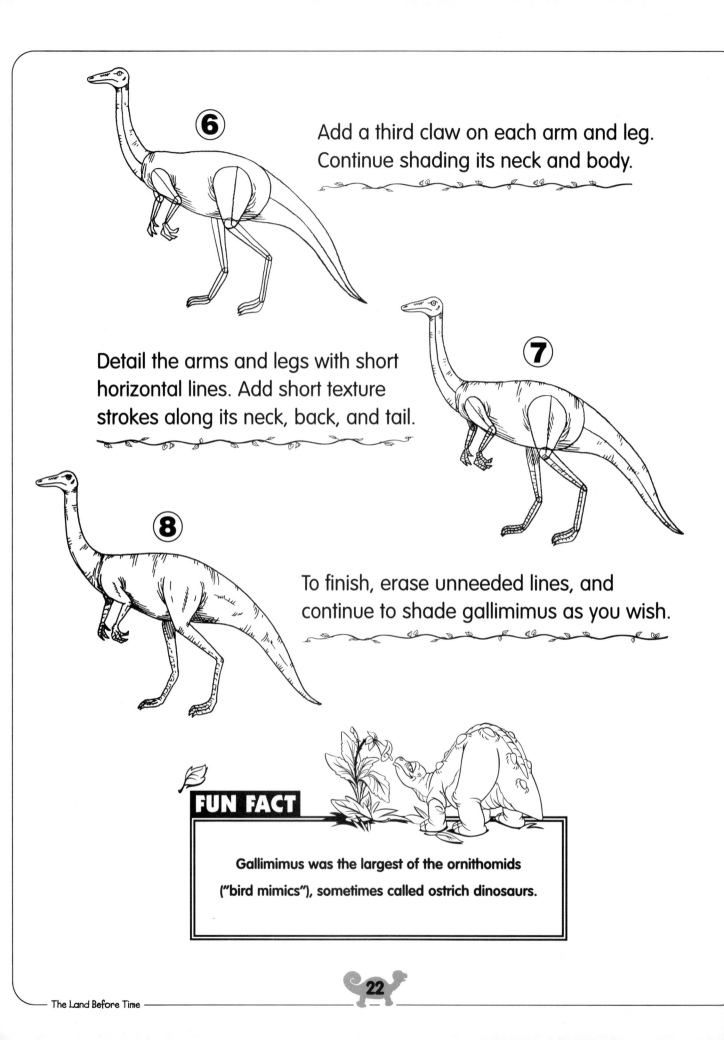

Hylaeosaurus

Hylaeosaurus was a 20-foot-long plant-eater. Plenty of fierce predators lived alongside this early Cretaceous critter, so it needed a way to protect itself. Any meat-eater that tried to take a bite would be in for a very unpleasant surprise. Hylaeosaurus' defense came in the form of spikes along its sides and two rows of sharp spines on its tail and hips.

① Draw its long body and head. Connect them with a short line, and add a long guideline for its tail.

Add four more guidelines for its legs. Begin to shape your dinosaur by outlining the tail, neck, and two near legs. Begin to detail the face.

②

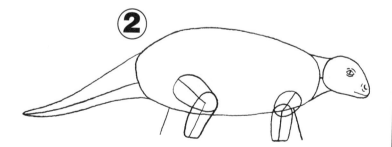

Outline the two far legs, and add shapes for toes on all four legs. Add large armored scales on its back and down its tail. Begin to shape its face as shown.

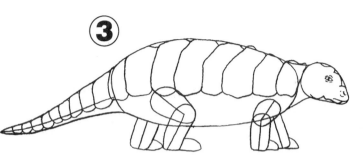

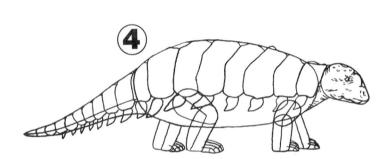

Add pointed spikes just below the scales as shown. Begin to detail the toes and claws, and further render its face and neck.

Sketch spots in the scales. Detail the dinosaur's underside, legs, and feet.

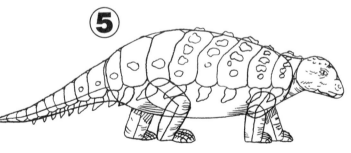

(6)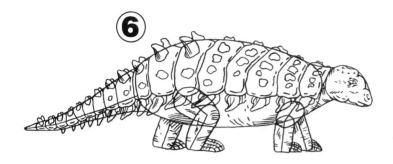

Add two rows of spikes along its back and tail. Continue to detail the scales, spikes, legs, and body.

Erase all unneeded lines, and finish the dinosaur with fine lines.

(7)

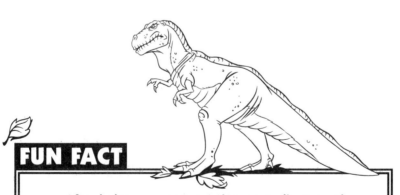

FUN FACT

After hylaeosaurus' remains were discovered in England, it was sent to the British Museum embedded in a solid block of limestone. Only the front half was found, and scientists had to guess what the rest might have looked like.

Iguanodon

Iguanodon was plentiful during the Cretaceous period and could be found on every continent except Antarctica. A peaceful plant-eater, iguanodon measured 30 feet in length and weighed in at about 5 tons. The three middle fingers of each hand ended in stubby hooves. The fifth finger could be used for grasping, and a sharp, bony thumb spike could be used as a weapon.

1

Draw the head and large body. Sketch guidelines for the neck, tail, legs, and near arm. Outline the neck and tail.

Outline the near arm and leg. Begin to detail the head with eyes, nostril, mouth, and slit behind the eye.

2

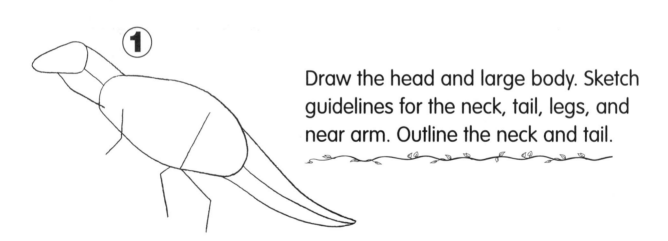

Continue to detail the face. Outline the far leg, and add foot and hand shapes as shown. Sketch wrinkles around the arm and leg joints.

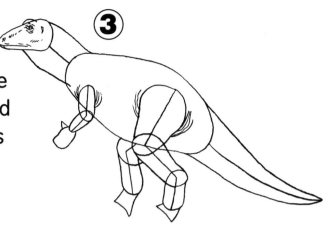

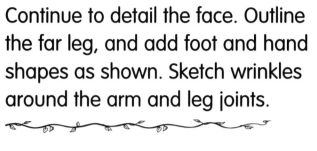

Add the far arm and its hand. Draw more texture lines around its body. Suggest a curved back. Begin to draw claws, one on each foot.

Add two more claws on each foot, and suggest claws in the hands. Shade the far arm and upper far leg. Continue detailing its body and neck.

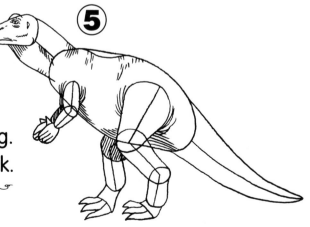

27

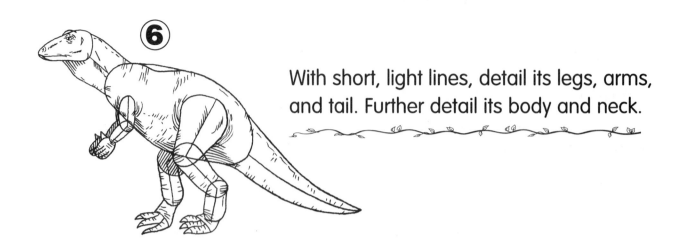

6

With short, light lines, detail its legs, arms, and tail. Further detail its body and neck.

Erase unneeded guidelines, and add finishing touches to your iguanodon.

7

FUN FACT

In 1854, a huge statue of an iguanodon was made to be displayed at an exhibition center in England so people could get an idea of what dinosaurs looked like. The statue was so big that before it was put on display, 20 guests had a special dinner party in the hollowed-out iguanodon.

Lambeosaurus

Lambeosaurus was a large duck-billed dinosaur. From nose to tail, it stretched about 30 feet and tipped the scales at 3 tons. It roamed the upland forests of North America during the late Cretaceous period, dining on low-growing plants. Lambeosaurus had a very unusual feature. Atop its head were an odd hatchet-shaped hollow crest and a backward-pointing solid spike.

①

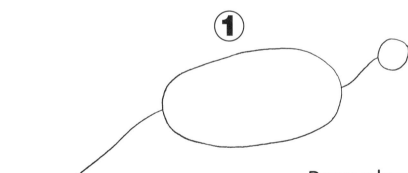

Draw a large oval for the body and a small circle for its head. Connect the two with a slightly curved line. Sketch a long guideline for the tail.

29

Outline the neck and tail. Draw a snout, spike, and large crest on top of its head. Add nostrils and an eye. Sketch guidelines for the two near legs.

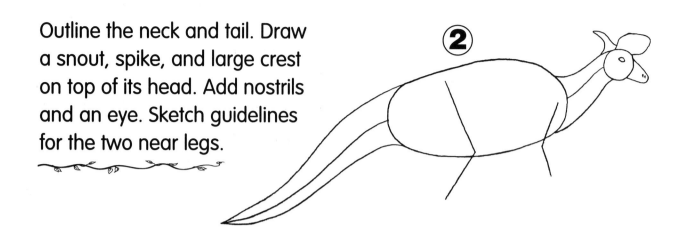

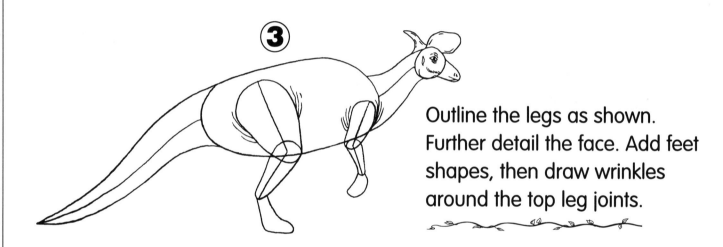

Outline the legs as shown. Further detail the face. Add feet shapes, then draw wrinkles around the top leg joints.

Add the far leg shapes. Further shape its underside as shown, and detail its crest.

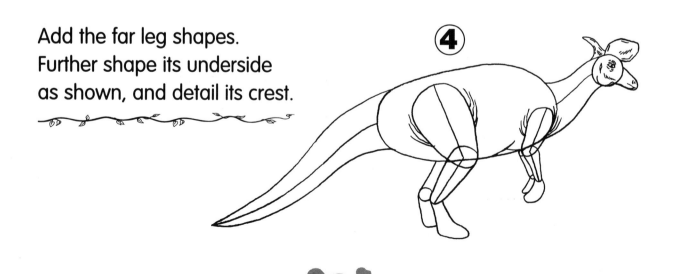

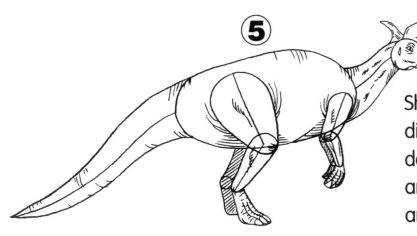

5

Shade in the far legs and the dinosaur's underside. Continue to detail its body, tail, neck, head, and legs. Draw the dinosaur's toes and claws on the two near legs.

Erase all unnecessary lines. Add finishing touches around lambeosaurus.

6

FUN FACT

Dinosaur fossils are rare in California, but a lambeosaurus was discovered in Baja, California, that may have been over 50 feet long.

A line of flat plates and rounded spikes protected the neck, back, and tail of lexovisaurus, and a pair of long spines protected its hips. This plant-eating, distant relative of stegosaurus lived in Europe during the Jurassic period. It was a small stegosaur, no longer than 16 feet from its stubby snout to its hefty tail.

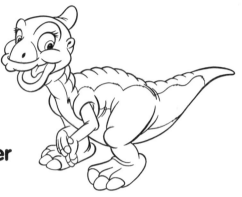

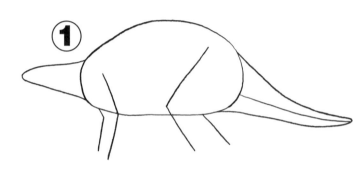

Draw a large bean shape for its body. Add a rounded triangular shape for its head and neck, and draw a guideline on the other end for its tail. Draw guidelines for the four legs, then outline the tail.

Outline the two near legs, and sketch guidelines for the two far legs. Begin to detail the facial features.

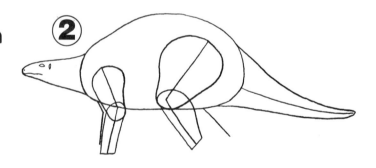

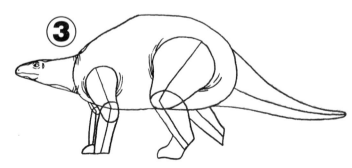

Shape the dinosaur's head and neck, and continue to detail its face. Fill in the dinosaur's far legs, and add toe shapes on the near legs. Begin to detail wrinkles around the neck and legs.

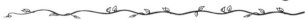

Add toe shapes on the far legs, then detail the toes. Draw large upright plates and spikes from its head to its tail. Begin to shade around its head, body, and legs.

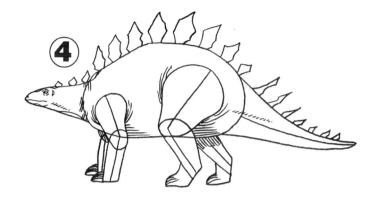

Further detail the toes and body. Begin to shade the plates and spikes.

Erase the unneeded lines. Finish detailing around its body, head, tail, legs, plates, and spikes.

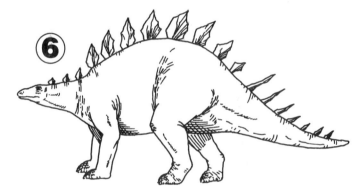

FUN FACT

Lexovisaurus remains were found in England and France.

It was named for the Lexovi tribe of northwestern France.

Ornithomimus means "bird mimic," and this slim, long-legged dinosaur did look a lot like an ostrich. Like the ostrich, ornithomimus was speedy. It stretched about 15 feet long (mostly neck and tail), and stood 8 feet tall. Its toothless, horny beak was perfect for crushing the fruit, eggs, insects, and small reptiles that it ate.

① Draw a horizontal shape for the body and a small circle to the right. Draw guidelines for the neck, tail, and near leg and arm. Add the upper portion of the beak.

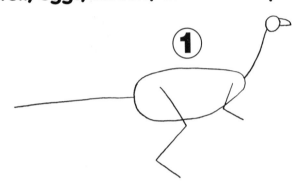

Outline the neck and tail. Draw the lower portion of the beak. Sketch a guideline for the far leg.

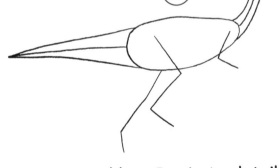
②

③ Outline the near arm and leg. Begin to detail the face, and further shape the beak area.

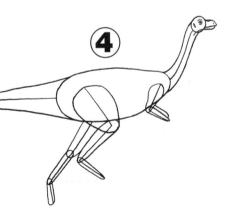
④

Add the far arm, and outline the far leg.

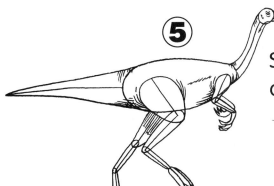

⑤ Sketch three long claws on **each of the legs** and arms. Begin shading the **dinosaur.**

Continue shading, and begin to add detail to the legs, arms, and claws using short horizontal lines.

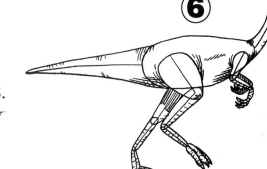

⑥

⑦

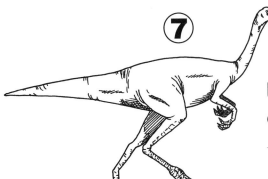

Erase all unneeded lines, and finish as desired.

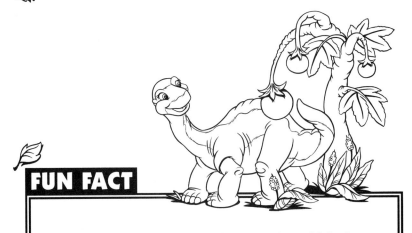

FUN FACT

Ornithomimus had a large brain cavity, which shows that, for a dinosaur, it was probably intelligent.

35

Ouranosaurus

The warm, dry climate of Cretaceous North Africa was home to ouranosaurus. A stocky relative of iguanodon, it had a 25-foot-long body and long, flat head. One thing made this plant-eater stand out from the others. A large sail grew from its back, running from neck to tail. The sail helped the dinosaur get rid of body heat when it was too warm and absorb heat from the sun when it was cold.

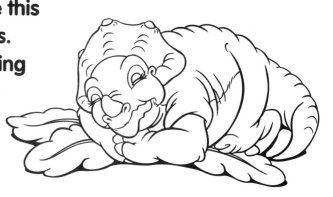

First draw the long body and its head. Connect the two, then add a guideline for its tail. Outline the neck and tail, and add guidelines for the near leg and arm.

Shape the near leg and arm, and add two guidelines for the far leg and arm. Begin to detail the face.

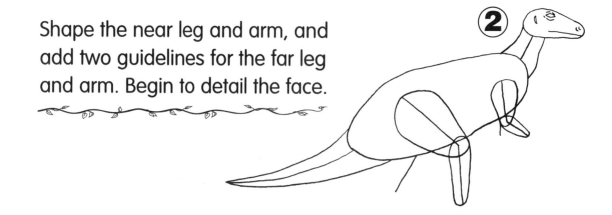

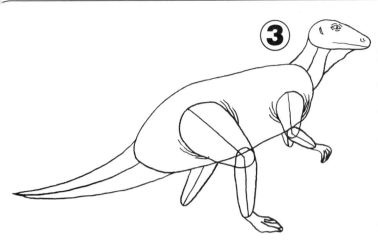

3 Shape the far leg and arm, then add claw shapes on the near leg and arm. Begin to detail the claws. Add an eye pupil and a fold of skin from its jaw to its neck. Draw wrinkles around the arm and leg joints.

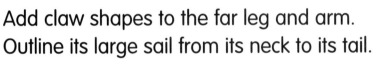

Add claw shapes to the far leg and arm. Outline its large sail from its neck to its tail.

4

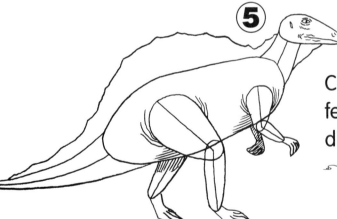

5 Continue to detail the facial features. Begin to shade the dinosaur's underside and far arm.

Begin to detail the dinosaur's legs, feet, and claws. Start to shade its head, neck, sail, and skin fold.

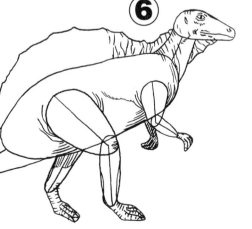

6

7

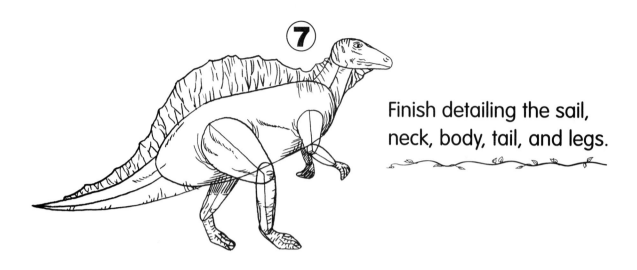

Finish detailing the sail, neck, body, tail, and legs.

Erase all extra guidelines. Add any finishing touches as needed.

8

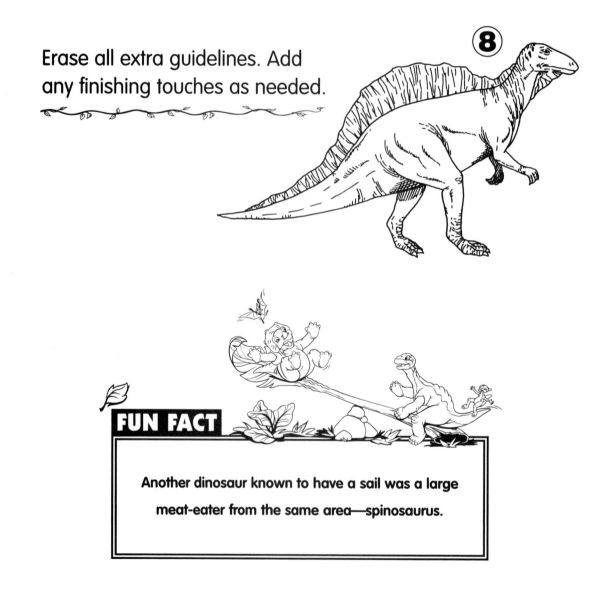

FUN FACT

Another dinosaur known to have a sail was a large meat-eater from the same area—spinosaurus.

Oviraptor

Oviraptor was 5 feet long, lightly built, and fast. Its slender, grasping fingers were tipped with sharp talons. A stubby hump rose from its toothless beak, and its short snout curved downward. It was an expert at snapping the bones of small prey or crushing egg shells.

1

Draw a rounded shape for the body and a small circle for the head. Draw guidelines for the neck and tail.

Sketch a snout, slightly overlapping it into the head. Outline the neck and tail. Draw guidelines for the legs and arm.

2

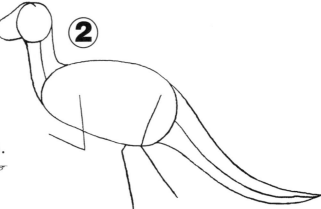

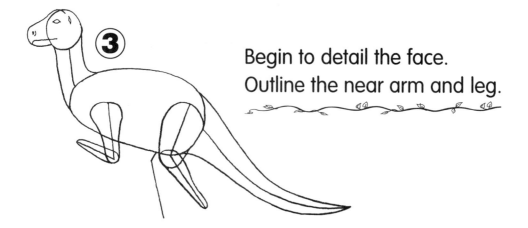

Begin to detail the face.
Outline the near arm and leg.

Add a small horn on the top of its snout. Shape its back with a curved line. Draw a small shape for the far arm. Shape the far leg.

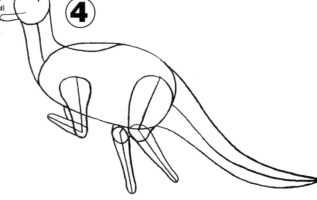

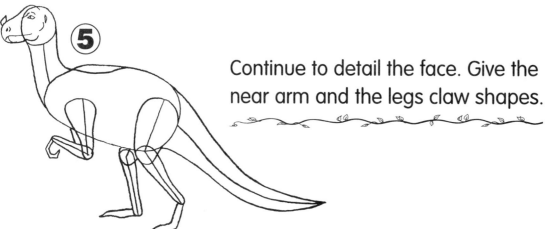

Continue to detail the face. Give the near arm and the legs claw shapes.

Add three more claws on the near hand (one is almost hidden), one claw for the far hand, and two on each foot. Begin to shade your oviraptor around its undersides and curved areas.

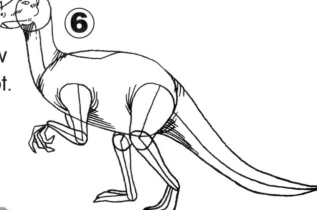

40

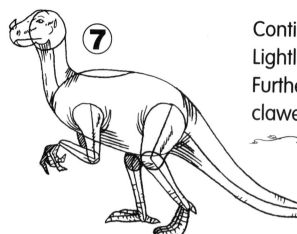

7 Continue shading your oviraptor. Lightly fill in the far arm and its claw. Further detail its toes and claws. Add clawed toes on the back of the feet.

Erase all guidelines, and finish shading.

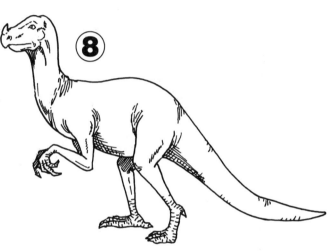

8

FUN FACT

In 1923, the remains of an oviraptor were found near what some scientists thought was a protoceratops nest. They thought the dinosaur was stealing eggs. However, it turned out to be an oviraptor nest. It was taking care of its own young!

Parasaurolophus

When it came to head gear, parasaurolophus of the Cretaceous period had a spectacular crown. Its slender skull supported a hollow crest that arched back in a graceful 4- to 6-foot-long curve. A slight ridge ran along its back, and it had a stout, sideways flattened tail. At 30 feet long and 3 to 5 tons, parasaurolophus was a hefty plant-eater. It ate pine needles and leaves with its spoon-shaped beak.

1 Draw the large body of this dinosaur and its smaller head. Add guidelines for the neck, tail, and near arm and leg. Give shape to the neck and tail.

2 Shape the near leg and arm, and add the eye and nostril. Outline the long crest extending from the back of its head.

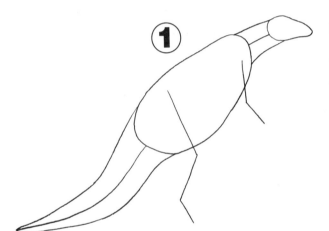

3 Draw in the far arm and leg. Add foot and hand shapes. Sketch wrinkles around the top arm and leg joints. Further detail its face.

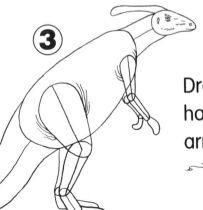

42

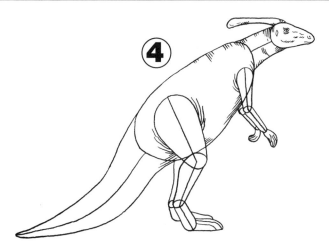

4 Begin to shade its underside, and continue to detail its crest, neck, and back. Suggest separate claws in the foot and hand shapes.

Continue detailing parasaurolophus. Shade the far arm and leg, and further render the claws.

5

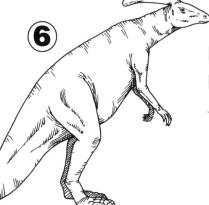

6 Erase all guidelines. Finish shading as shown.

FUN FACT

Parasaurolophus' crest may have enabled the dinosaur to make a loud, trumpeting call.

How to Draw Dinosaurs

Protoceratops

Protoceratops was a small member of the horned dinosaur group. It didn't have a true horn, but some had a small bony bump on the face. A parrotlike beak tipped protoceratops' snout and was well suited for shearing off twigs and leaves of low-growing plants. It also had a bony frill that protected the back of its neck. During the early Cretaceous period, this sheep-sized dinosaur lived in what is now Asia.

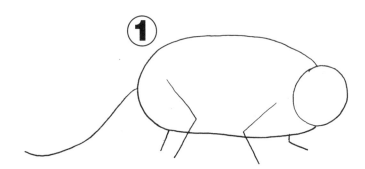

① Draw a circle for the dinosaur's head. Draw a long horizontal shape for its body. Add guidelines for its legs and tail.

From its head, draw a hooked beak. Draw outlines around the tail and three upper legs.

②

3

Add its lower legs, and draw its frill behind its head.

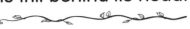

Draw four long toes on each of the feet (no toes can be seen on the back left foot). On the face, draw an eye, nostril, and lower jaw.

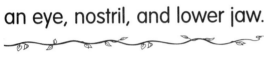

4

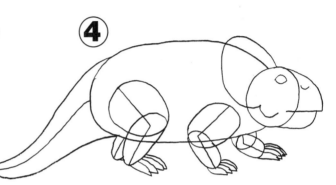

5

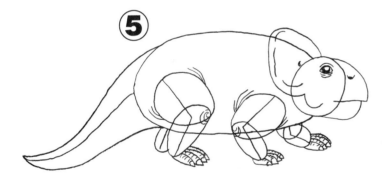

Begin to detail the frill. Add a pupil in the eye. Sketch in claws on the toes. Detail the pupil and nostril as shown. Start to add wrinkles around its legs and feet.

Continue adding wrinkles on the frill, body, tail, and legs. Add a curved dotted line on its beak.

6

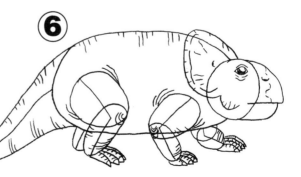

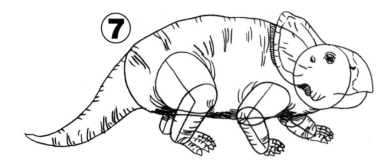

⑦ Begin to shade the dinosaur, and draw more wrinkles.

Erase the guidelines and any other unneeded lines. Add more shading behind the frill and on the underside of the body.

⑧

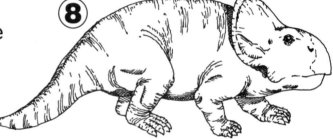

FUN FACT

The skull of a newborn protoceratops was no more than an inch long.

Saltopus

Saltopus was no bigger than a house cat. This Triassic lightweight was 2 feet long and weighed about 2 pounds. At 8 inches high, it was tiny enough to fit in a backpack, but that would probably be a bad idea. It may have been small, but its slim jaws were lined with sharp teeth. It had five grasping fingers on each hand, a long neck, and large eyes. Often hunting in packs, saltopus chased and devoured insects, lizards, and anything else it could catch.

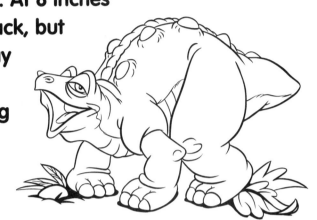

Draw a small circle for the head of saltopus and a larger shape for its body. Add guidelines for the neck and tail.

Add a snout, then draw guidelines for the legs and near arm. Outline the neck and tail.

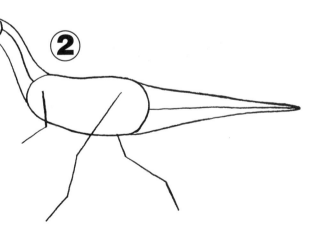

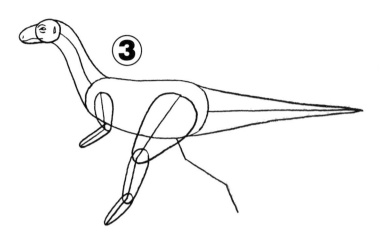

③

Begin to detail the face with an eye, nostril, mouth, and slit behind the eye. Outline the near arm and leg.

Sketch the far arm, and outline the far leg. Continue to detail the face, and add detail to the neck.

④

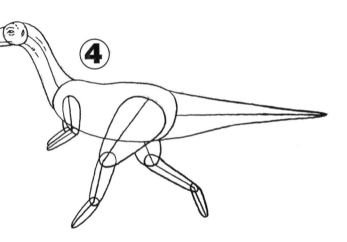

⑤

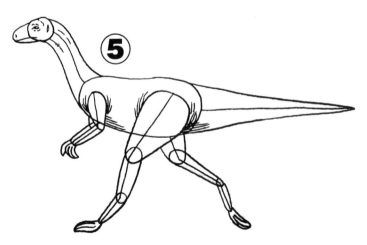

Draw foot and hand shapes, and suggest claws. Shade the underside of saltopus and around its arm and leg joints.

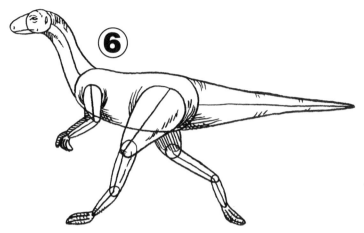

6

Continue to detail its face and neck, as well as the body, feet, and tail. Don't forget to shade the far arm and upper portion of the back leg.

Erase all extra lines, then detail your creature as needed.

7

FUN FACT

Saltopus is among the oldest known dinosaurs.

Stegosaurus

Stegosaurus was a plated dinosaur of Jurassic North America. It was about 30 feet long and weighed about 3 tons. Its best weapons were at the end of its tail. There it displayed two to four pairs of sharp spikes that were each about 3 feet long. Stegosaurus' most obvious characteristic was a staggered row of bony plates that lined its back. The plates added protection, but they were most helpful in controlling the dinosaur's body temperature.

To begin, draw a large rounded shape for the body and a very small circle for its head. Draw guidelines for the neck and tail.

Sketch guidelines for the four legs. In the face, draw an eye, nostril, and mouth. Outline the neck and tail.

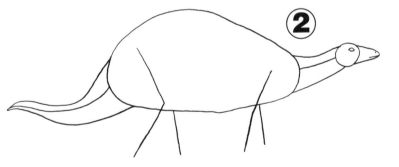

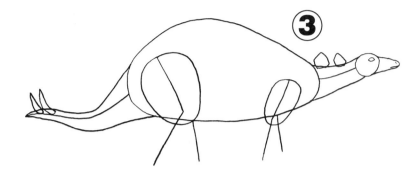

3 Begin to detail stegosaurus with bony plates on its neck and two pointed spikes on its tail. Outline the upper portions of the near legs.

Continue adding plates down its back and tail. Fill in the lower portions of the near legs, and add toes on the feet.

4

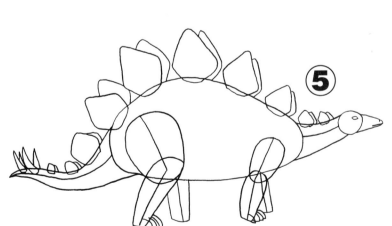

5 Suggest a second set of plates behind the first set and two more pointed spikes on its tail. Outline the two far legs.

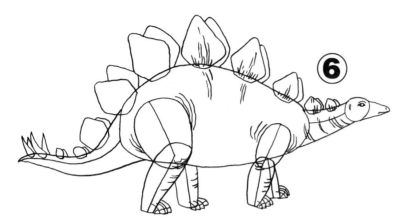

6

Begin to detail the plates, neck, legs, and body. Continue to render the face, and suggest claws on the feet.

To finish, erase all unneeded lines. Shade its underside and the far set of plates. Add any finishing touches you wish.

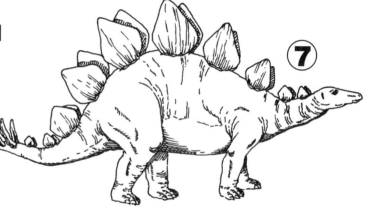

7

FUN FACT

Stegosaurus' brain was about the size of a golf ball and probably weighed 2 or 3 ounces.

52

Styracosaurus

A short frill with six long spikes at the edge crowned styracosaurus, or "spiked lizard." A four-legged Cretaceous plant-eater, styracosaurus was a bulky animal some 18 feet long and 6 feet tall. It weighed about 3 tons. It was no lightweight in the defense department either. Its snout was tipped with an impressive horn that was 2 feet long and 6 inches thick. This dinosaur roamed in herds. A hungry predator would probably think twice before attacking such a group of bulky animals bristling with sharp horns.

①

Draw the odd-shaped body, with a small circle overlapping it. Sketch in guidelines for the tail and four legs. Give shape to the tail.

Draw its beaked snout and mouth. Outline the near legs.

②
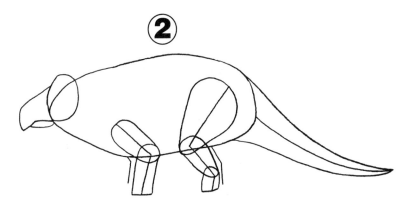

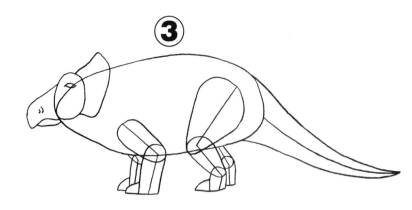

③

Outline the far legs, and add toe shapes as shown. Draw an eye, nostril, and large frill behind the head.

Add a horn on its snout, and detail its eye. Draw two points on the frill. Begin to sketch the toes as shown.

④

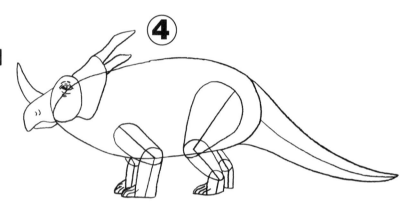

⑤

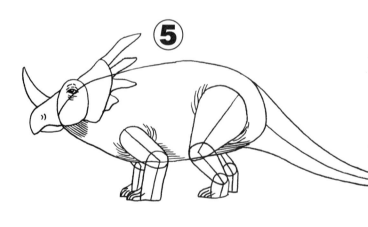

Continue to add points to the frill. Shade under its body and neck. Begin to add detail around its legs.

Add two more points on the frill, one above the first and one directly below it. Draw shadows under two of the points. Detail its near legs and toes.

⑥

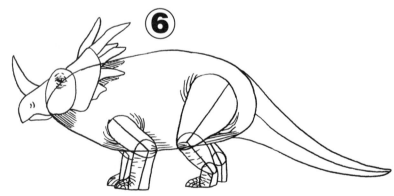

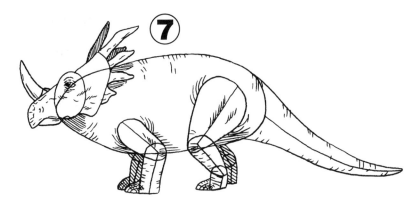

⑦

Shade the first and third points on the frill. Add detail to the horn and face. Shade the two far legs, and continue detailing the dinosaur.

Erase all guidelines. Add finishing touches as desired.

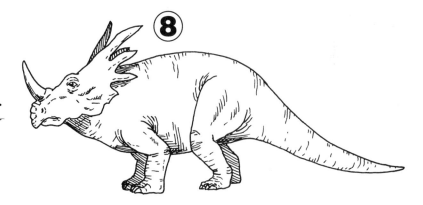

⑧

FUN FACT

One likely purpose for the horns on styracosaurus' frill was to make the animal look larger and more ferocious to frighten enemies.

Triceratops

Triceratops means "three-horned face." Take a look and you'll see why this 8-ton behemoth got its name. A stubby horn sprouted from its snout and two 4-foot-long horns grew above its eyes. It also had a short bony frill. The skull on 25-foot-long triceratops took up almost one-third of that length. The Cretaceous dinosaur's snout ended in a curved, horn-covered beak for clipping tough branches, leaves, and twigs. It could easily snap a 2-inch sapling in half with one bite. A battery of short cheek teeth ground the food into small digestible pieces.

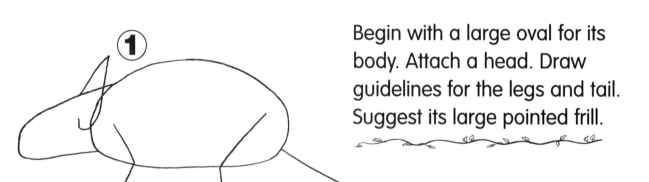

Begin with a large oval for its body. Attach a head. Draw guidelines for the legs and tail. Suggest its large pointed frill.

56

Outline the tail and upper legs. Draw three horns on its head. Suggest a small eye and nostril.

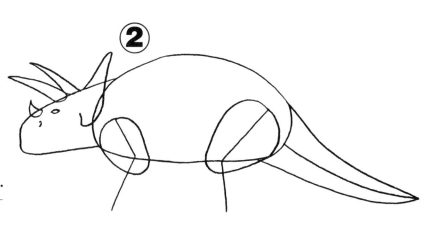

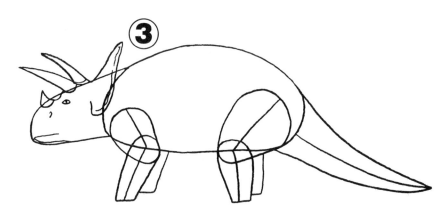

Outline the lower portions of its legs. Add its far legs. Detail the face with a mouth and a pupil in the eye. Further shape the head, and detail the frill.

Continue to detail the frill and face. Draw wrinkles around the legs, and add foot shapes.

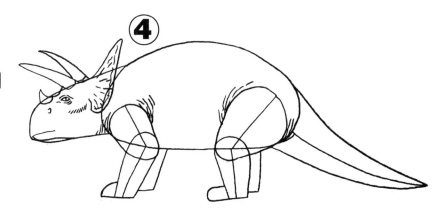

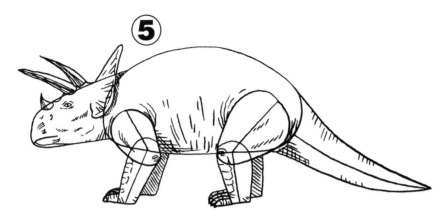

⑤

Shade the far legs, and suggest toes and claws. Continue detailing triceratops, including its horns.

Finally, erase all unneeded lines. Finish with any additional shading or texturing.

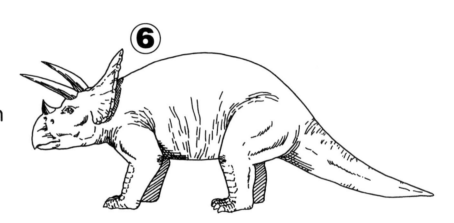

⑥

FUN FACT

Triceratops' skull alone weighed more than a ton.

58

Tyrannosaurus Rex

If there was a king of the Cretaceous period it was tyrannosaurus rex, or "king of the tyrant lizards." This huge 40-foot-long meat-eater towered over its prey. It made short work of a meal by slicing through and tearing the flesh with its wickedly sharp teeth. Each curved tooth was serrated like a steak knife. The only thing that didn't fit T-rex's giant image was its arms. Even though its hands ended in two claw-tipped fingers, the arms were no bigger than the arms of a human.

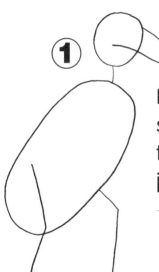

Draw a long oval for the body and a small circle for the head. Connect the two, then draw a shape for its upper jaw. Add guidelines for its legs.

Add guidelines for its arms, and begin to draw its lower jaw.

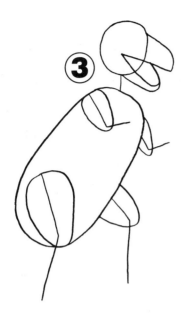

3

Finish its lower jaw, and begin to fill in the upper arms and legs.

Fill in the wide neck, as well as the lower portions of its arms and legs.

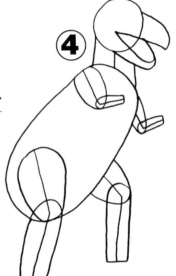

4

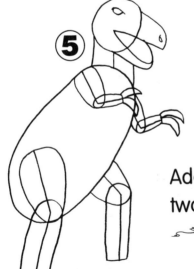

5

Add an eye and nostril. Sketch two large claws on each arm.

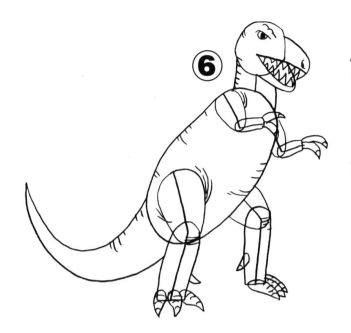

6

Add four claws on each foot. Begin to detail the claws on the hands. Draw in a pupil and teeth, and darken the nostril. Add some texture lines around T-rex.

Erase all guidelines. Shade in the large jaw and undersides. Further render the clawed hands and feet. Detail your dinosaur as desired.

7

FUN FACT

A tyrannosaurus' teeth could be as long as 7 inches.

Velociraptor, or "fast thief," was named for its speed and grasping hands. But if you saw this 6-foot-long predator, you'd be more likely to notice the sharp, curved claw on each back foot. It used the claws to tear and slash at its prey. In some ways it was like bigger raptors, except for its head, which was long and low. It also had fewer teeth than others of its kind. Still, velociraptor was well equipped to be a small but fearsome predator.

①

Draw an oval for velociraptor's body and a small circle for its head. Connect the two with a thin line. Draw a guideline for its tail, and its near arm and leg. Outline the neck and tail.

Outline the near arm and leg. Draw its far arm and leg. Create a squarish shape for its long snout, and add eyes. Sketch the open mouth, and add nostrils. Draw a small slit behind the eye.

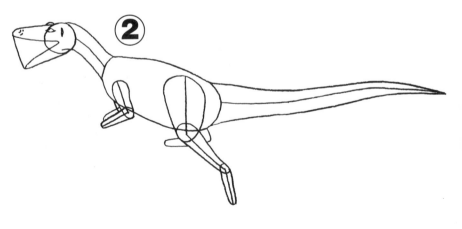

②

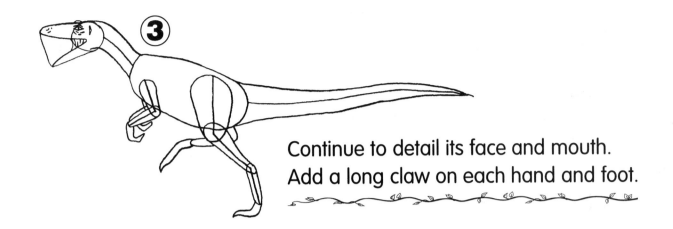

③

Continue to detail its face and mouth.
Add a long claw on each hand and foot.

Further detail the head,
also adding teeth. Draw
a second claw on each
hand and foot.

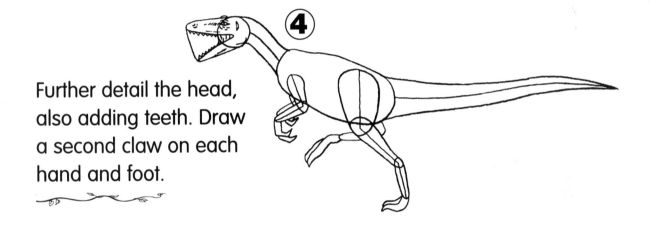

④

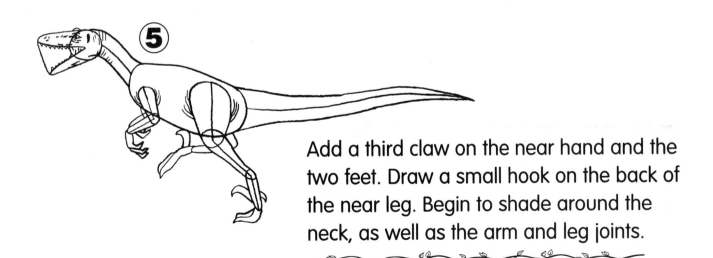

⑤

Add a third claw on the near hand and the
two feet. Draw a small hook on the back of
the near leg. Begin to shade around the
neck, as well as the arm and leg joints.

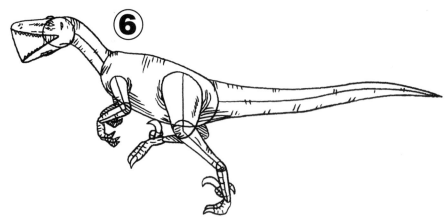

6

Begin to detail the claws on the hands and feet. Shade in the far arm and leg. Lightly shade its underside. Add texture lines around its tail, back, legs, and arms.

7

Erase the guidelines. Continue to shade as needed.

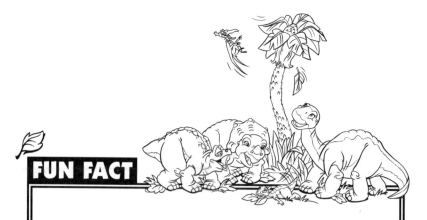

FUN FACT

The fossil remains of a velociraptor have been found locked with those of a protoceratops. Both animals must have died while battling each other.